Volume 4 of the Inspired Art Coloring Books Series - Fantasy.

My art in this book was fantasy inspired. I like asking people what kind of things they like, places I hang out at, or seeing a flowering tree. The world is an amazing place. I hope that you find my images as beautiful as I do, while creating them.

Depending on your background, culture, mind set, you might see something completely different within each image. My art style was created over 25 years ago, inspired by the old method of creating silk screens. It was amazing to me that we could create such wonderful images out of pieces. That our minds can connect individual lines and merge them into the wonderful pieces of art. As I developed my style, it became how I say the energy and flow of things. An under lying base of life. People have seen many different cultural and artistic influences from around the world in my art. It makes my heart warm when I hear all the different things people see in my style.

In some of my images the negative space is the focus of the drawing, so when you are coloring don't limit yourself to only coloring in the lines. There is no wrong way to color. Let the colors flow how it feels right to you.

Some people don't see what I intended the image to be, instead find wonderful things I didn't see until they pointed them out to me. The last page has all art listed with what the main image is of. But don't look at it until you decide what each art piece is first.

Each page can be cut out and framed so you can display your colored creations.

The art is printed on one side of the paper.

Recommend using cardstock or multiple sheets of paper to stop bleed-through to the next page. You can test on the last few pages in the book.

Thanks
Brian Scott

Copyright @ 2017 Brian Scott
All rights reserved. No Part of this book may be reproduced or transmitted in any for by any means, electronic or mechanical, including photocopying, scannning and recording, or by any information storage and retrieval system, without permission in writing from the publisher, except for the review for inclusion in a magazine, newspaper or broadcast

ISBN: 9781098850524

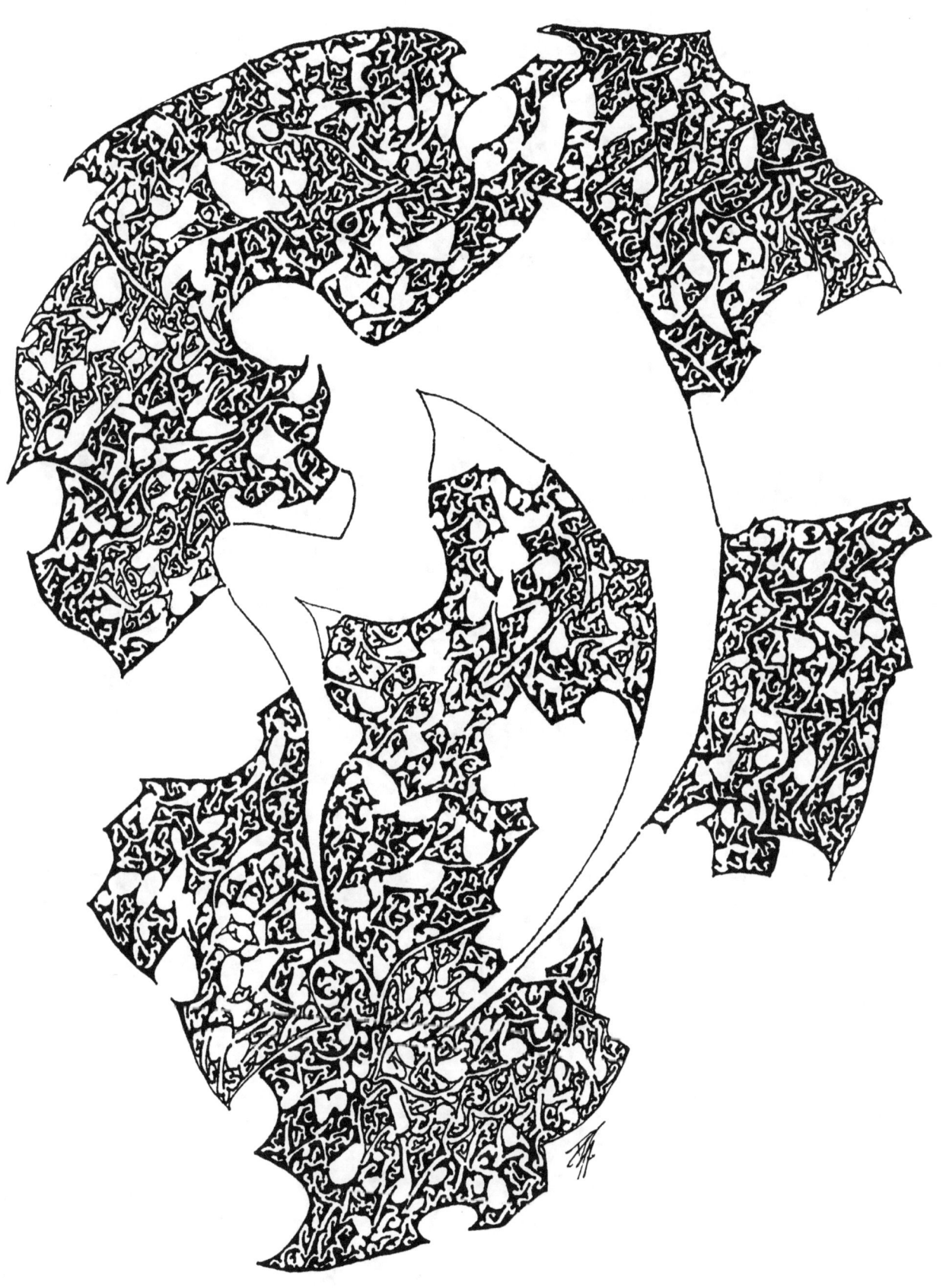

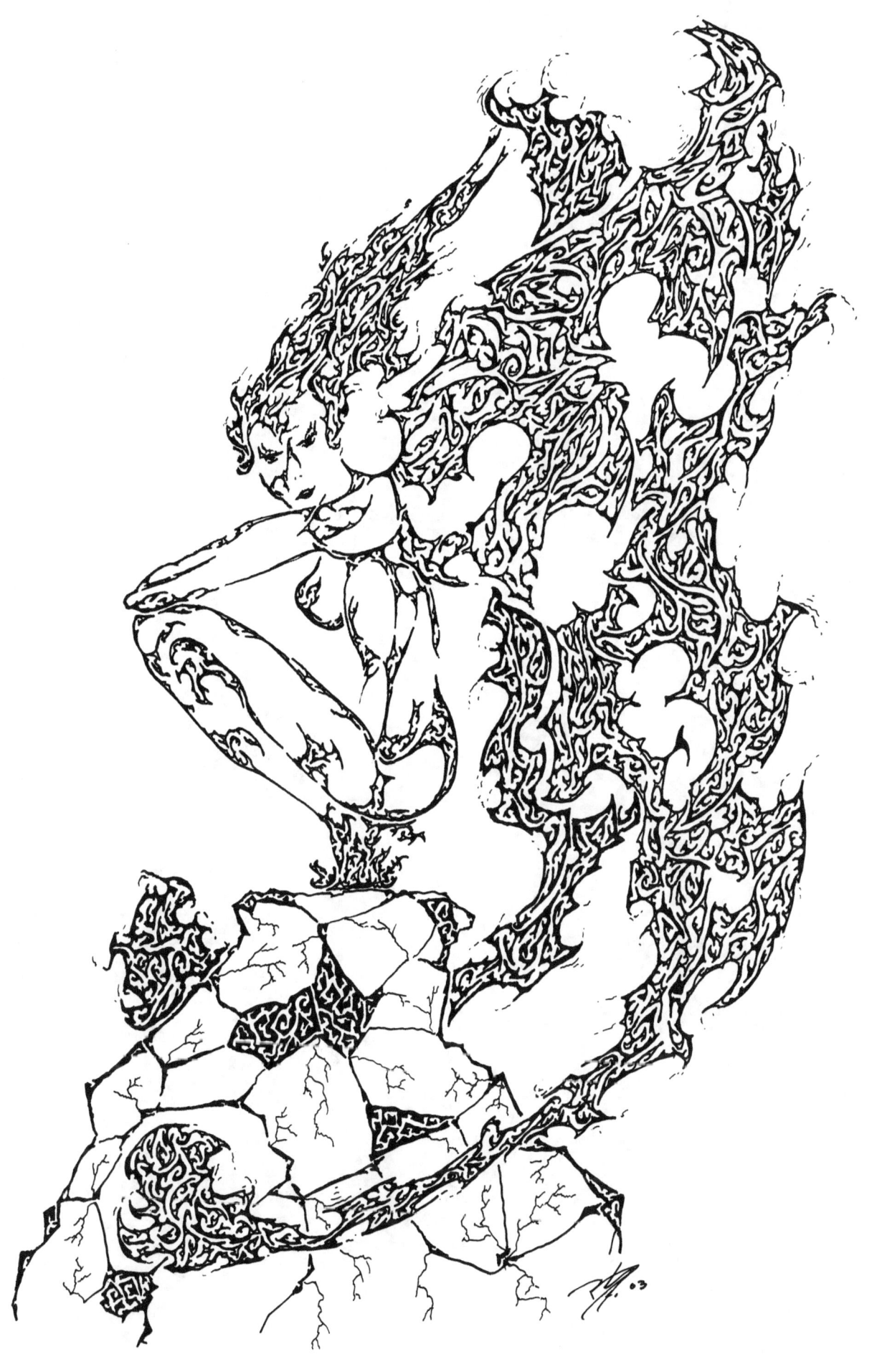

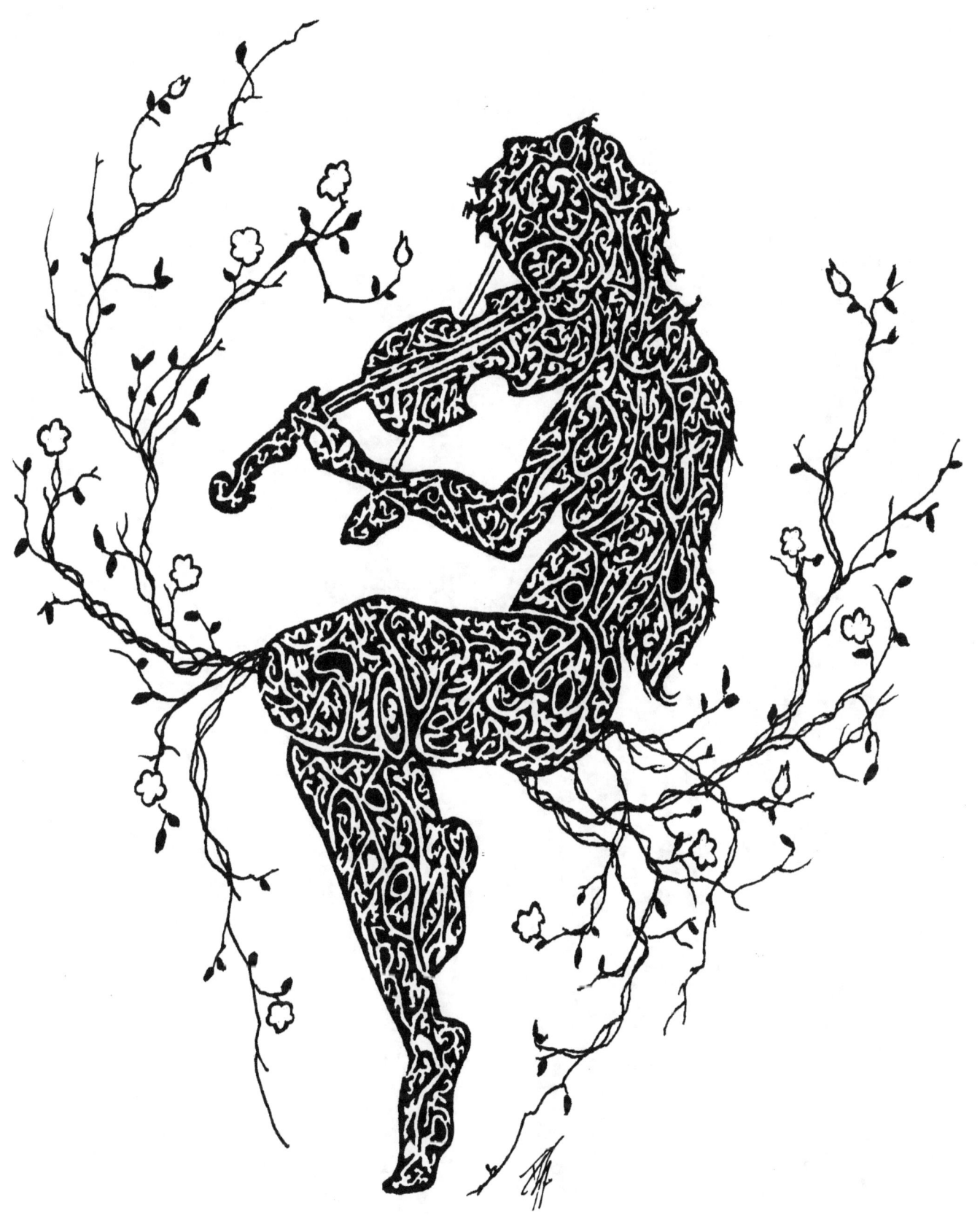

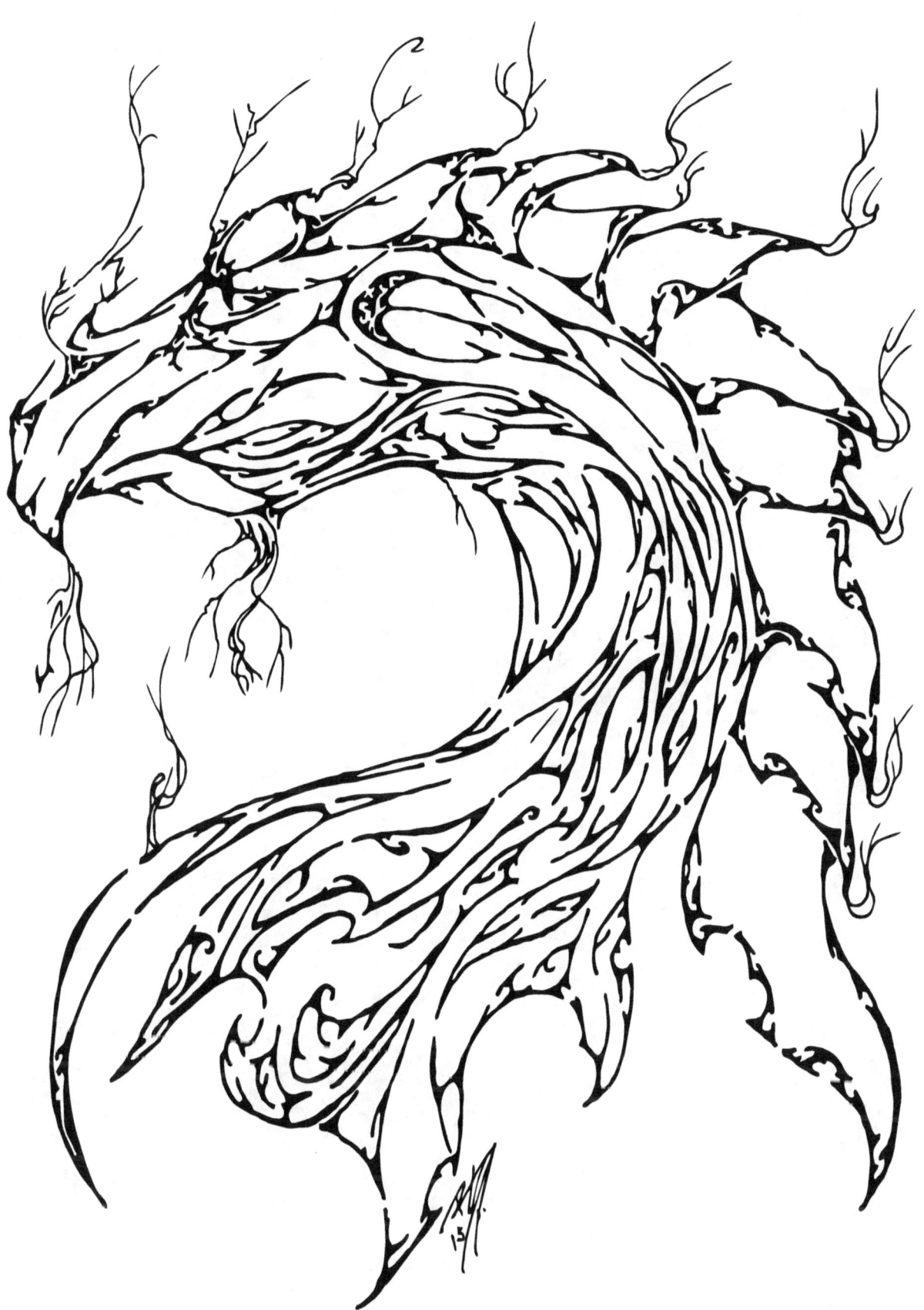

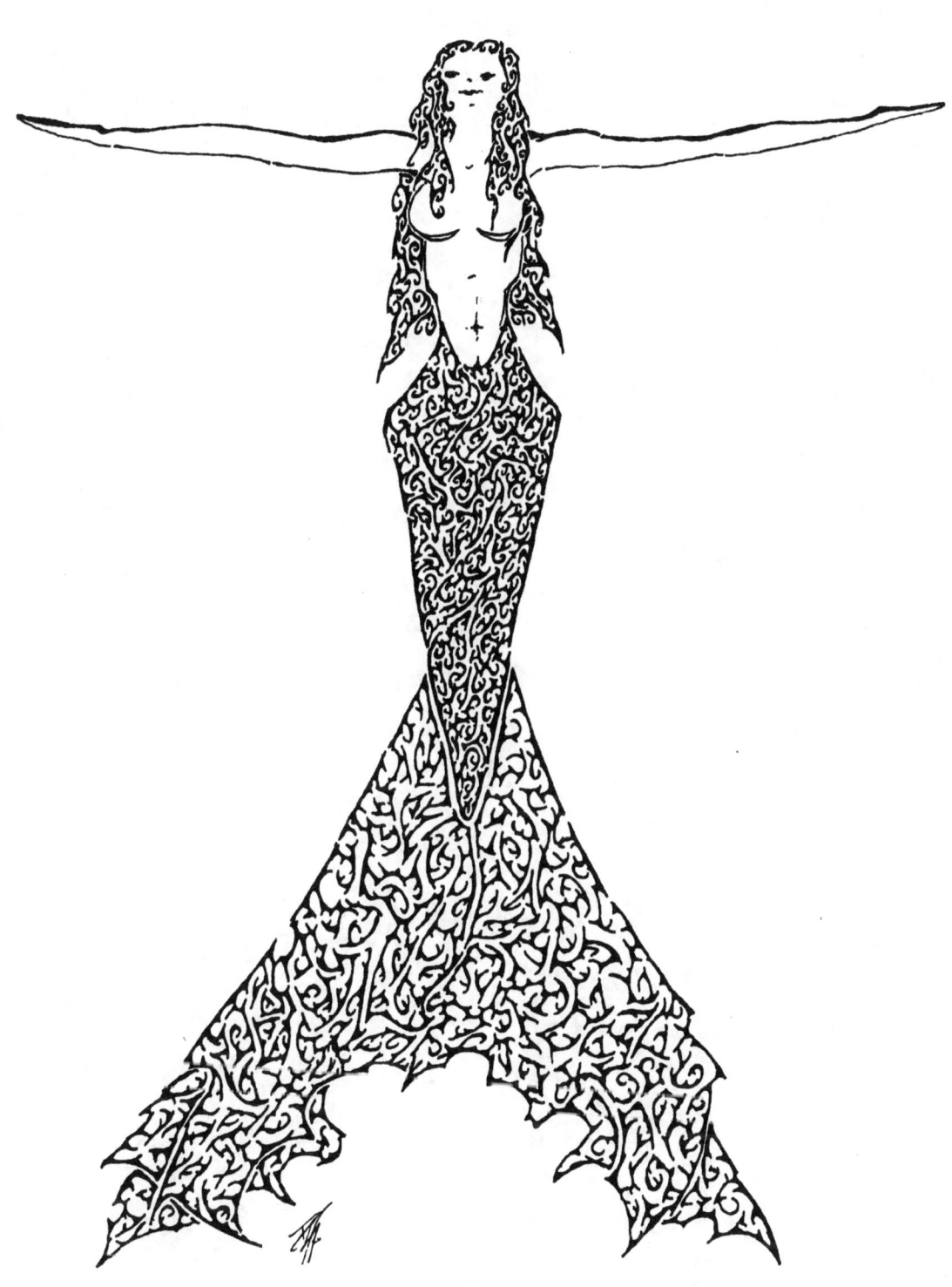

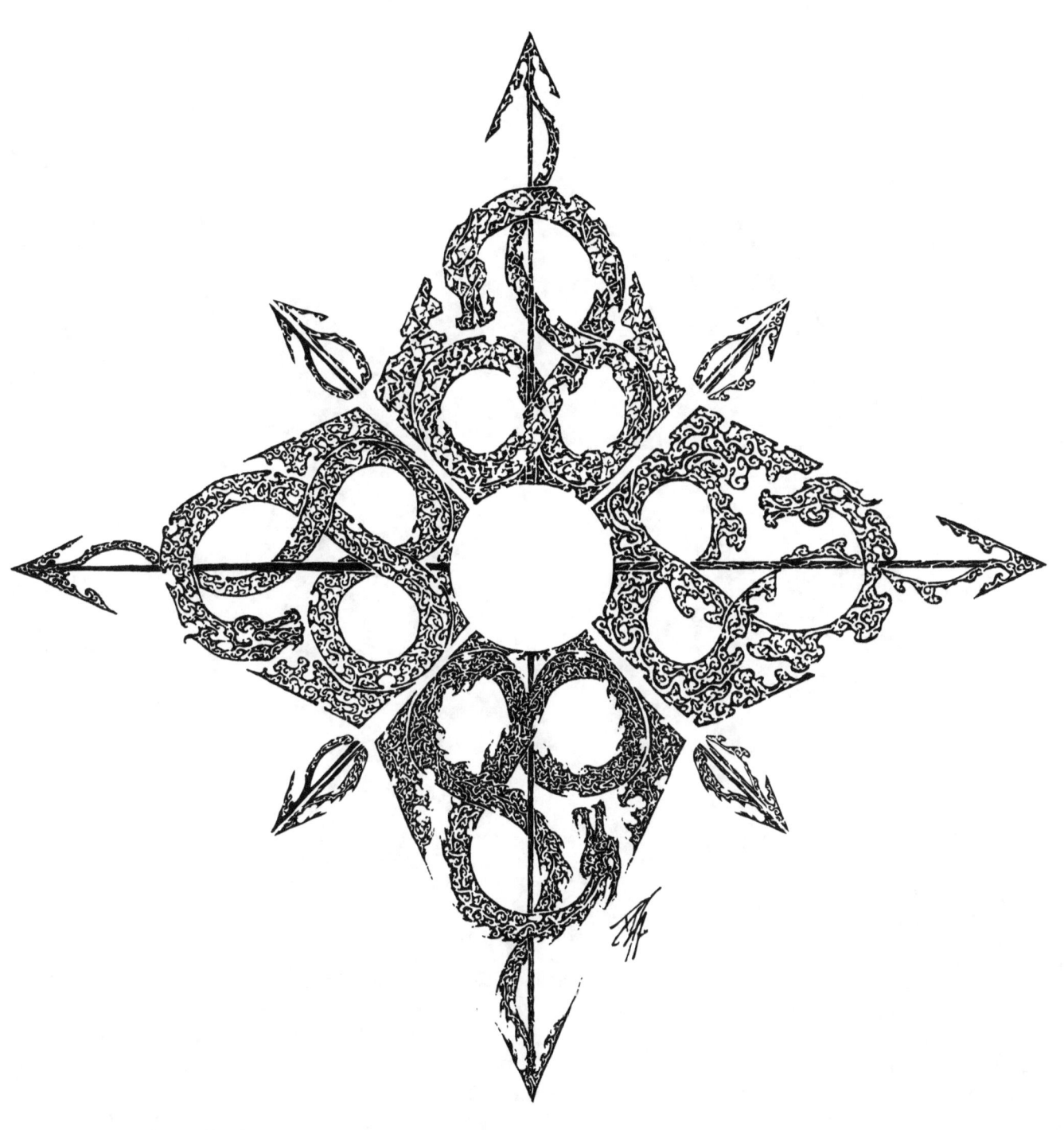

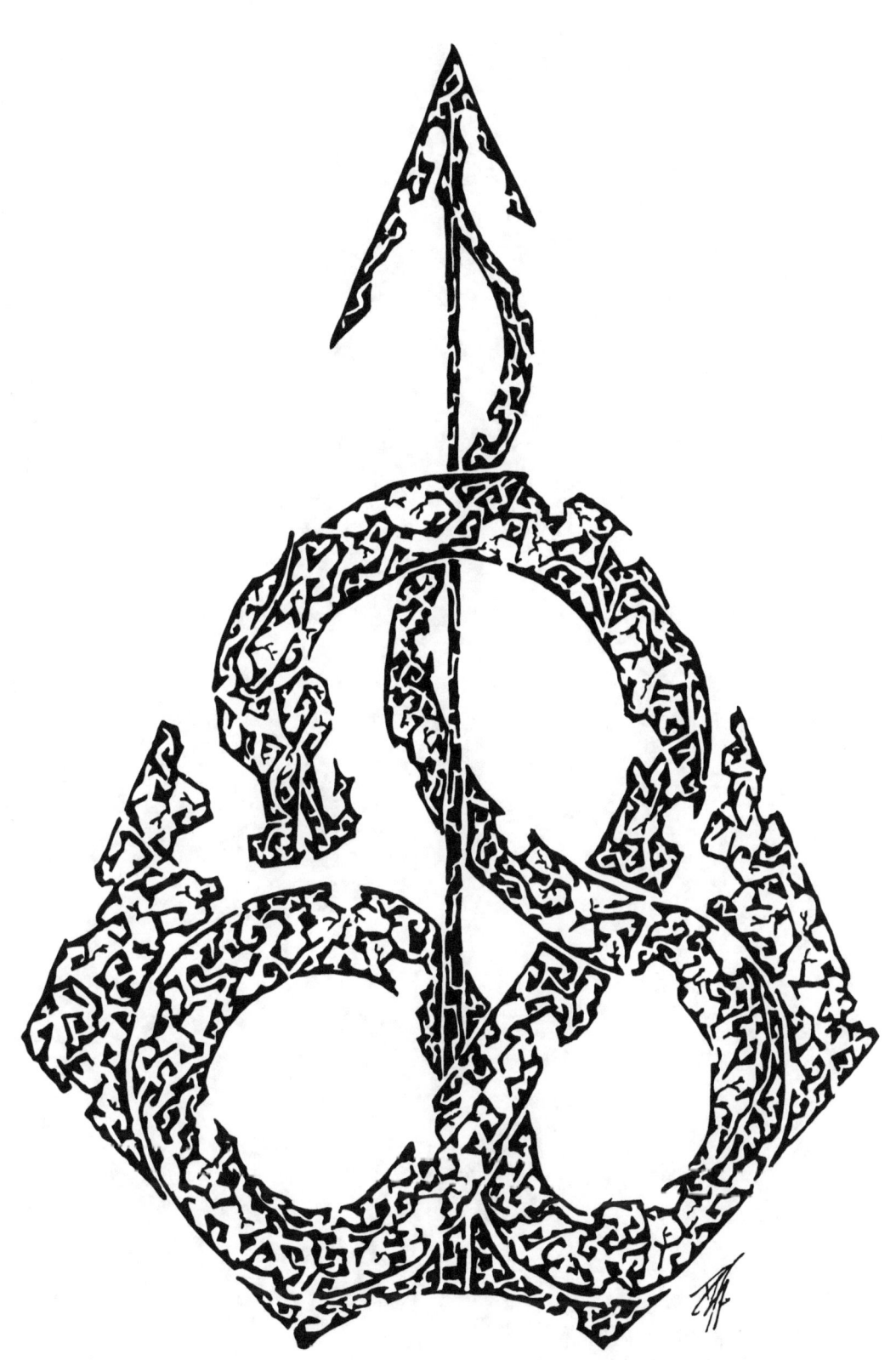

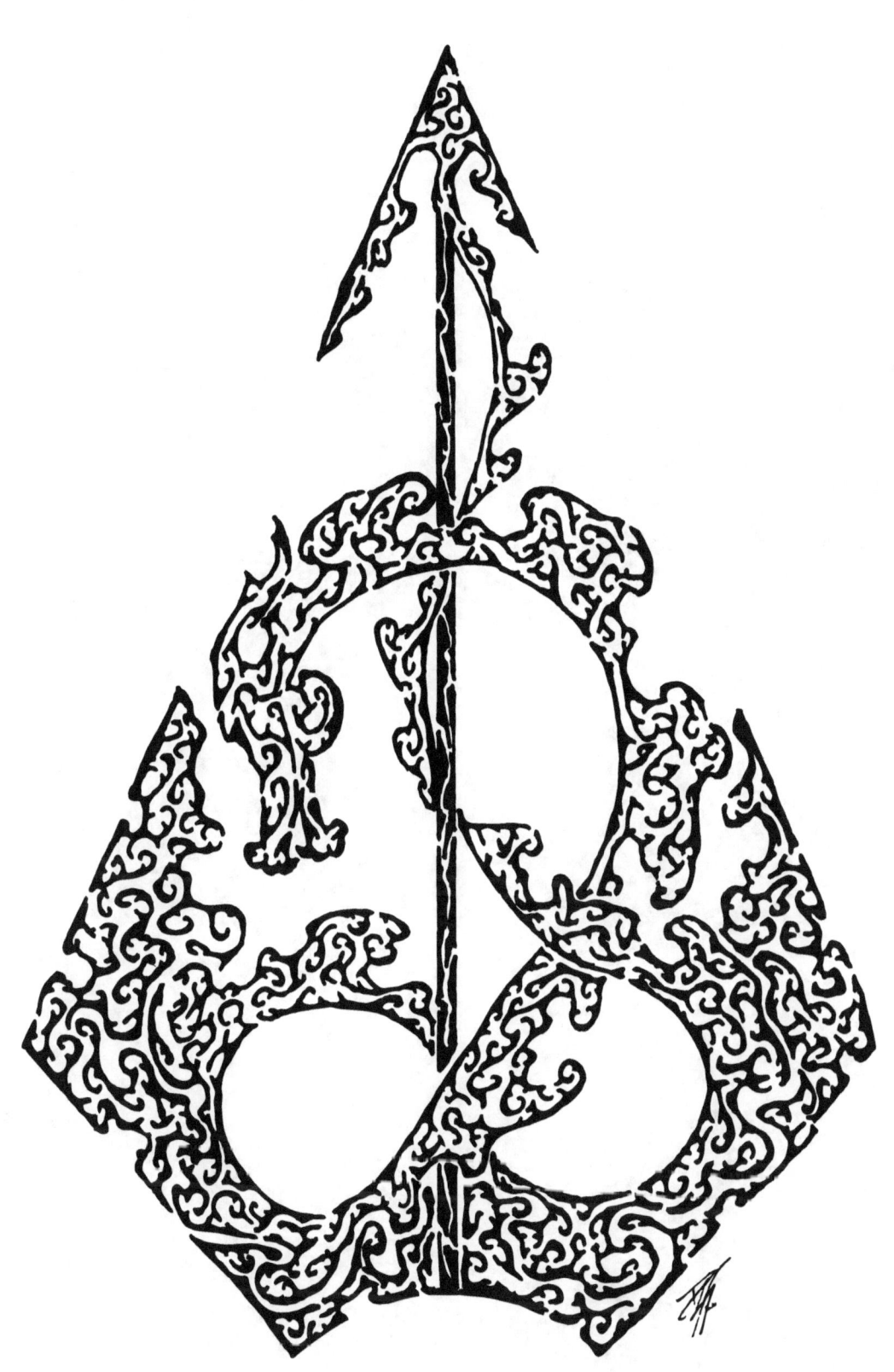

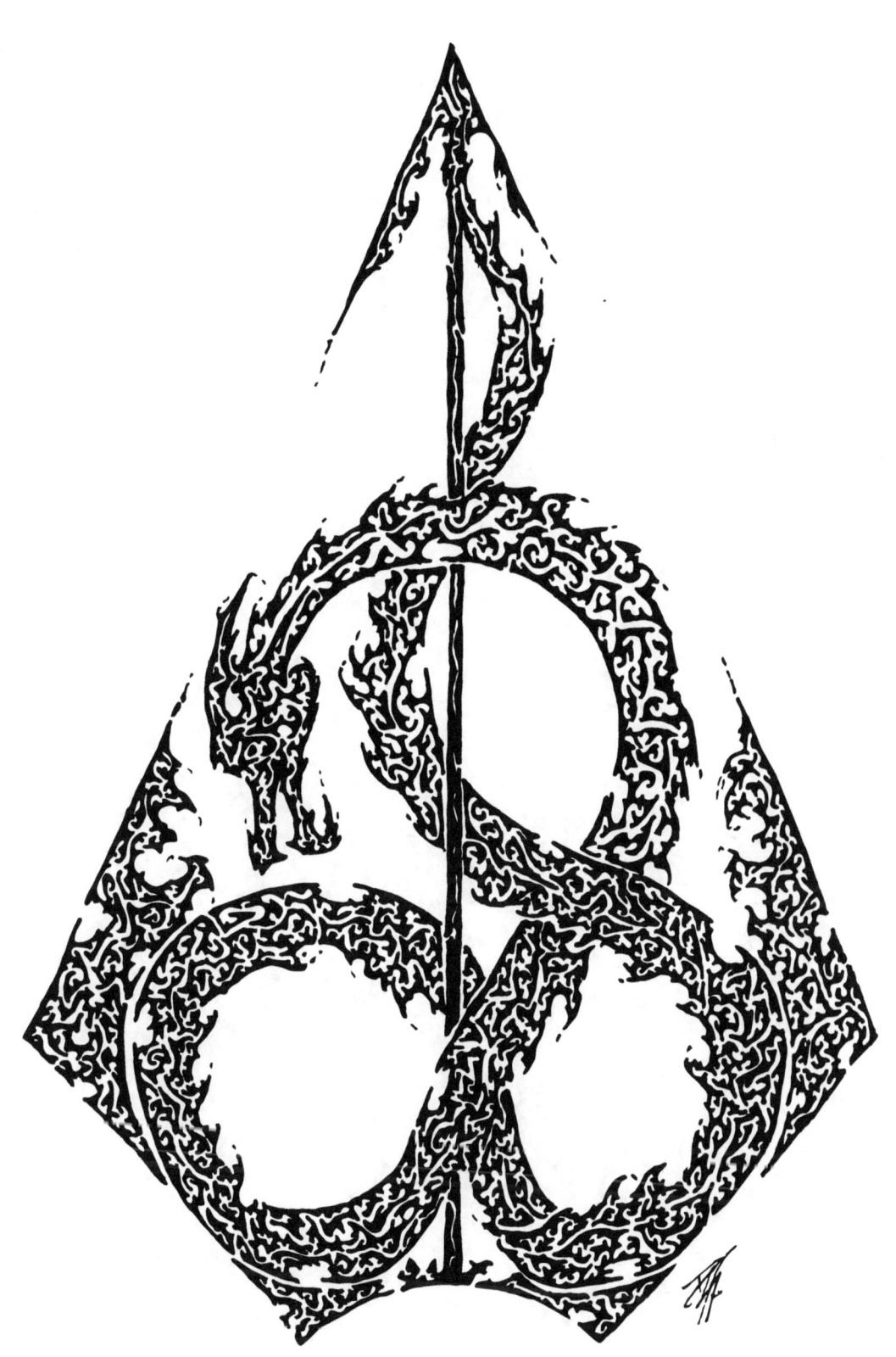

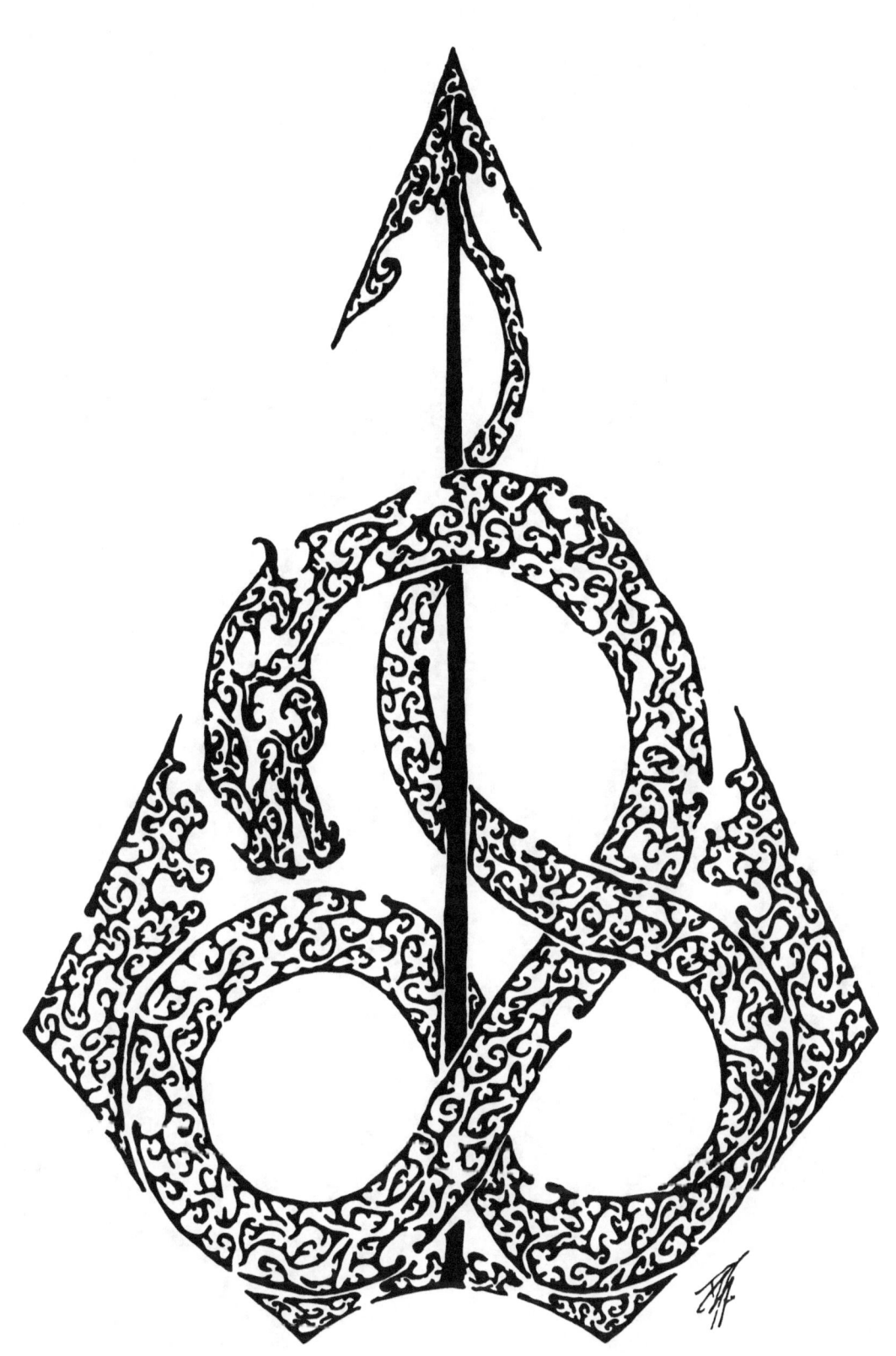

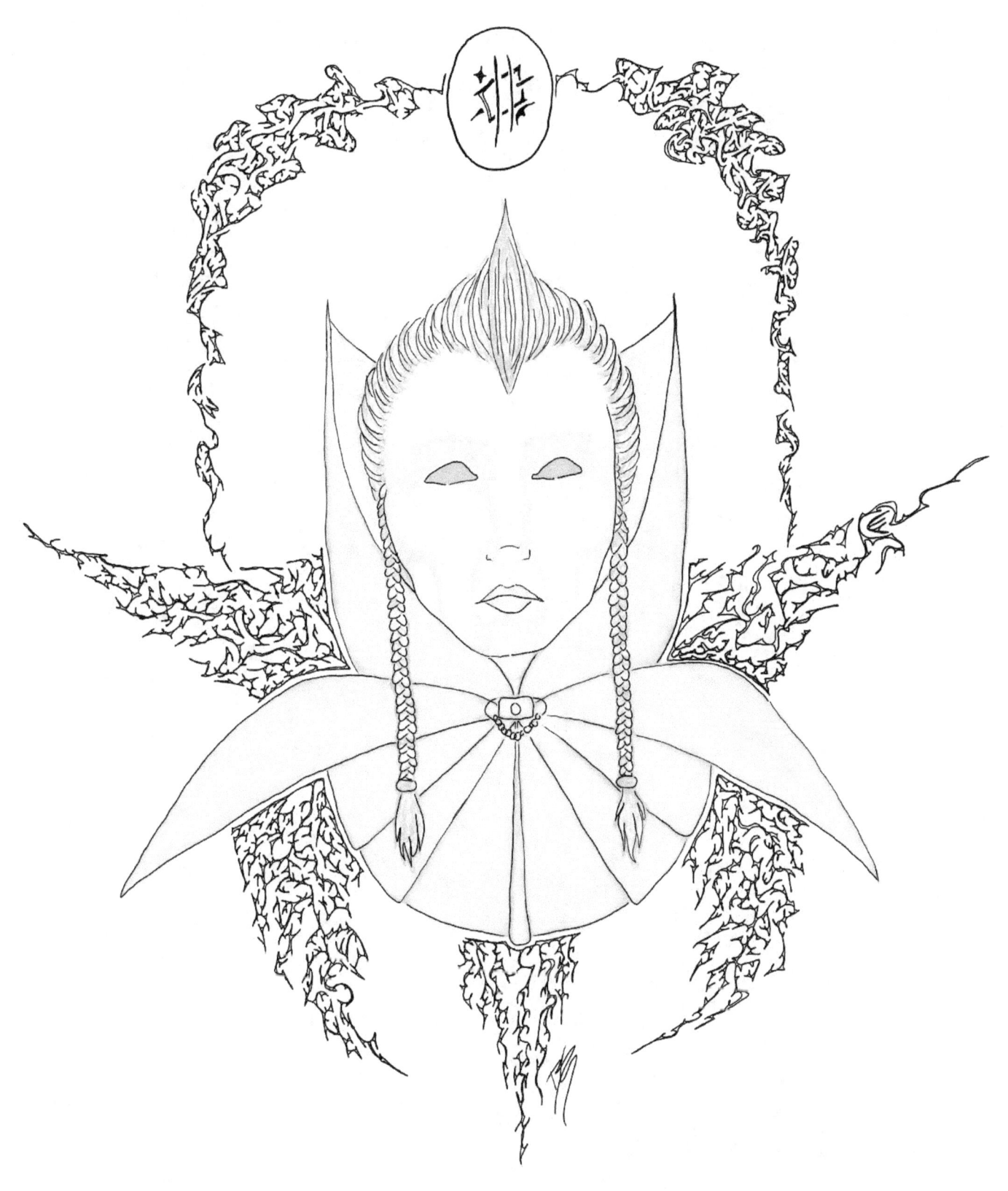

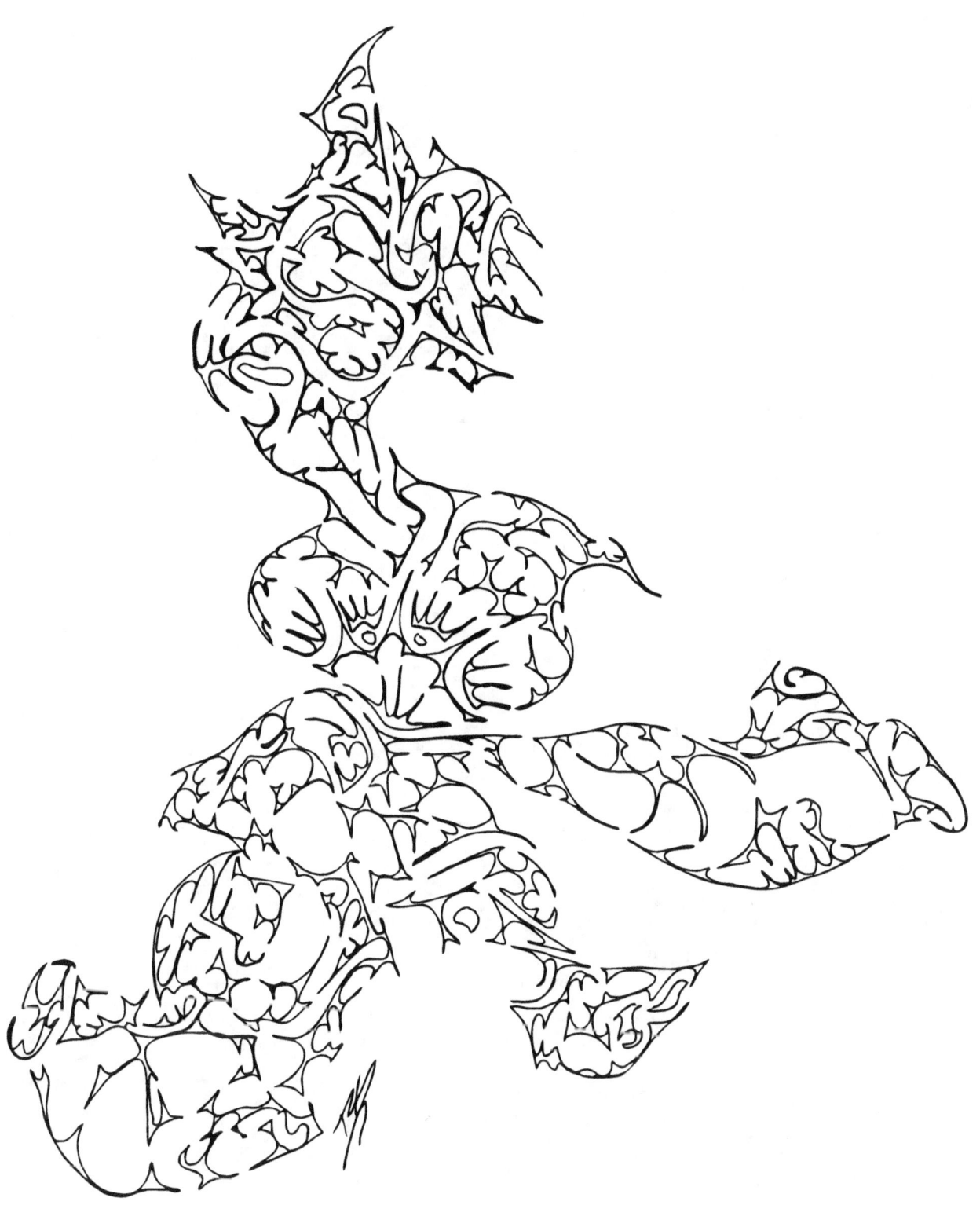

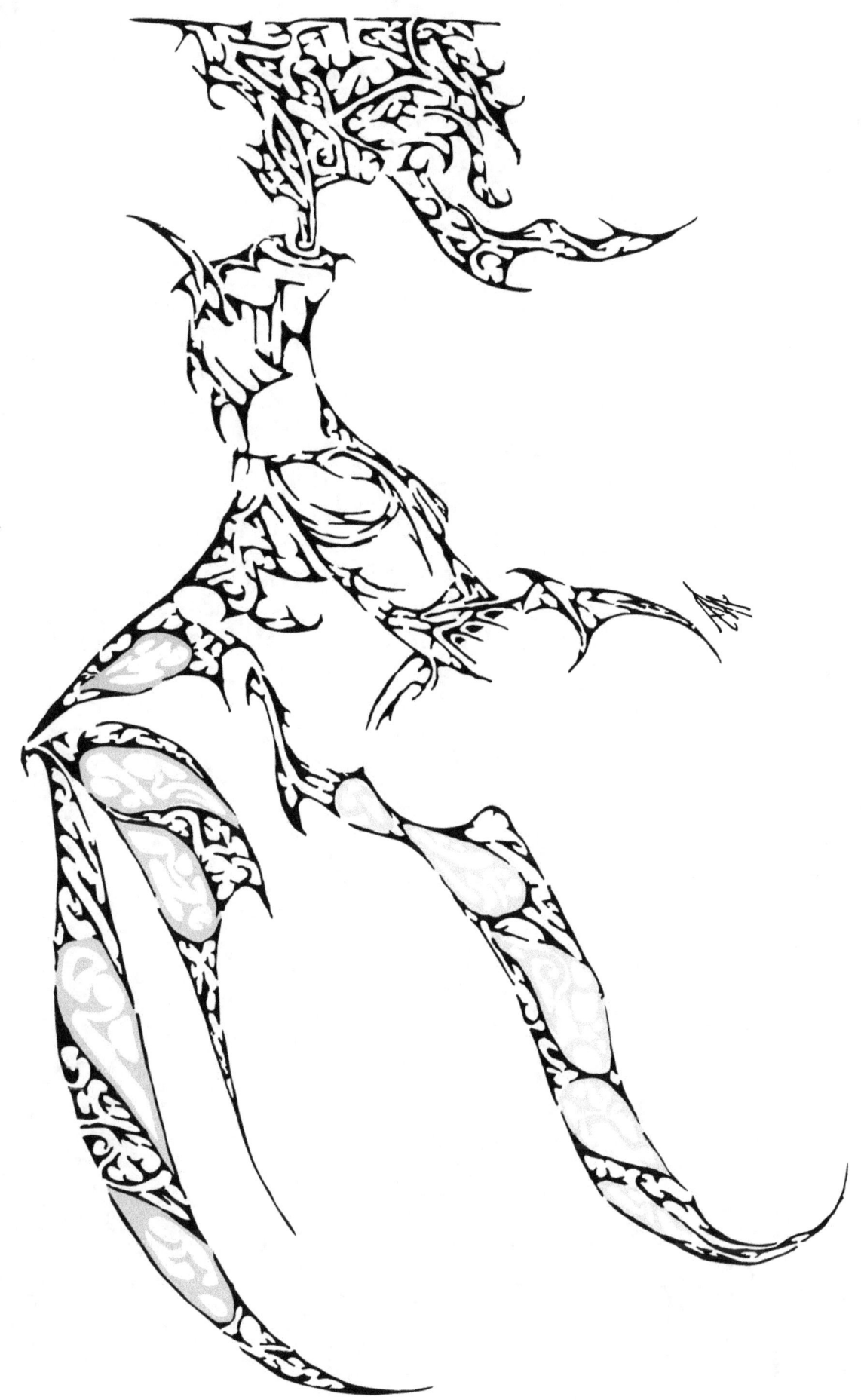

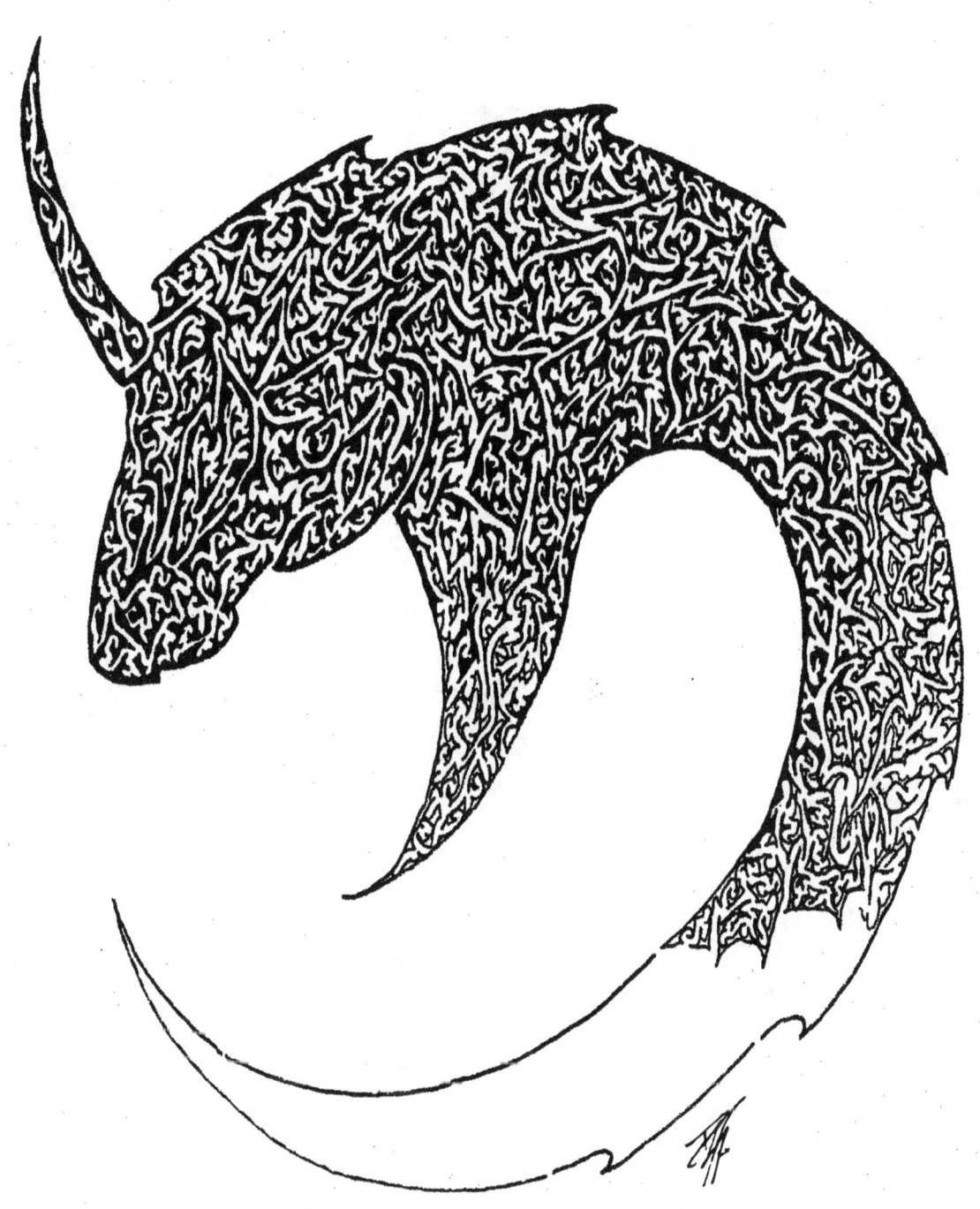

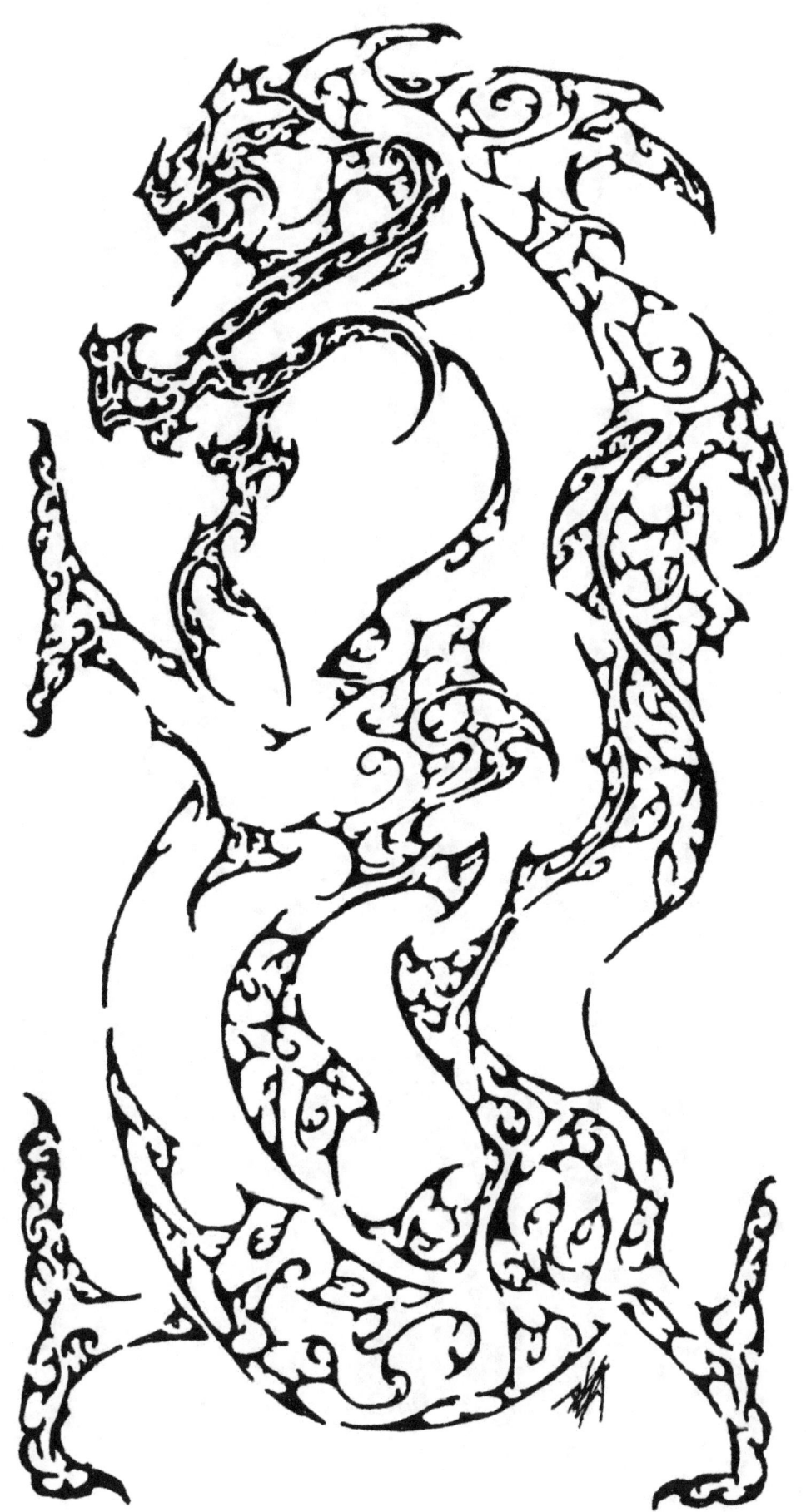

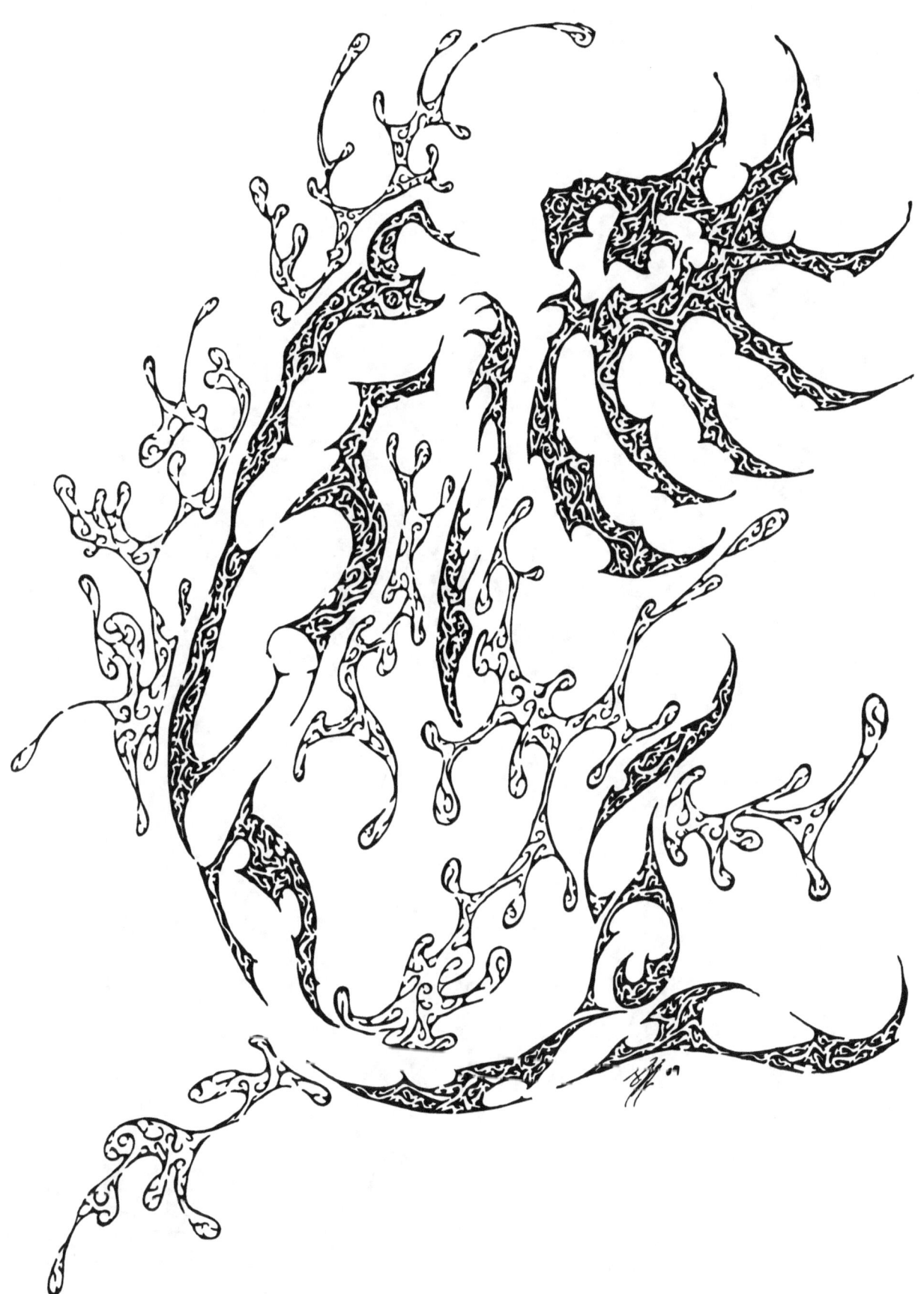

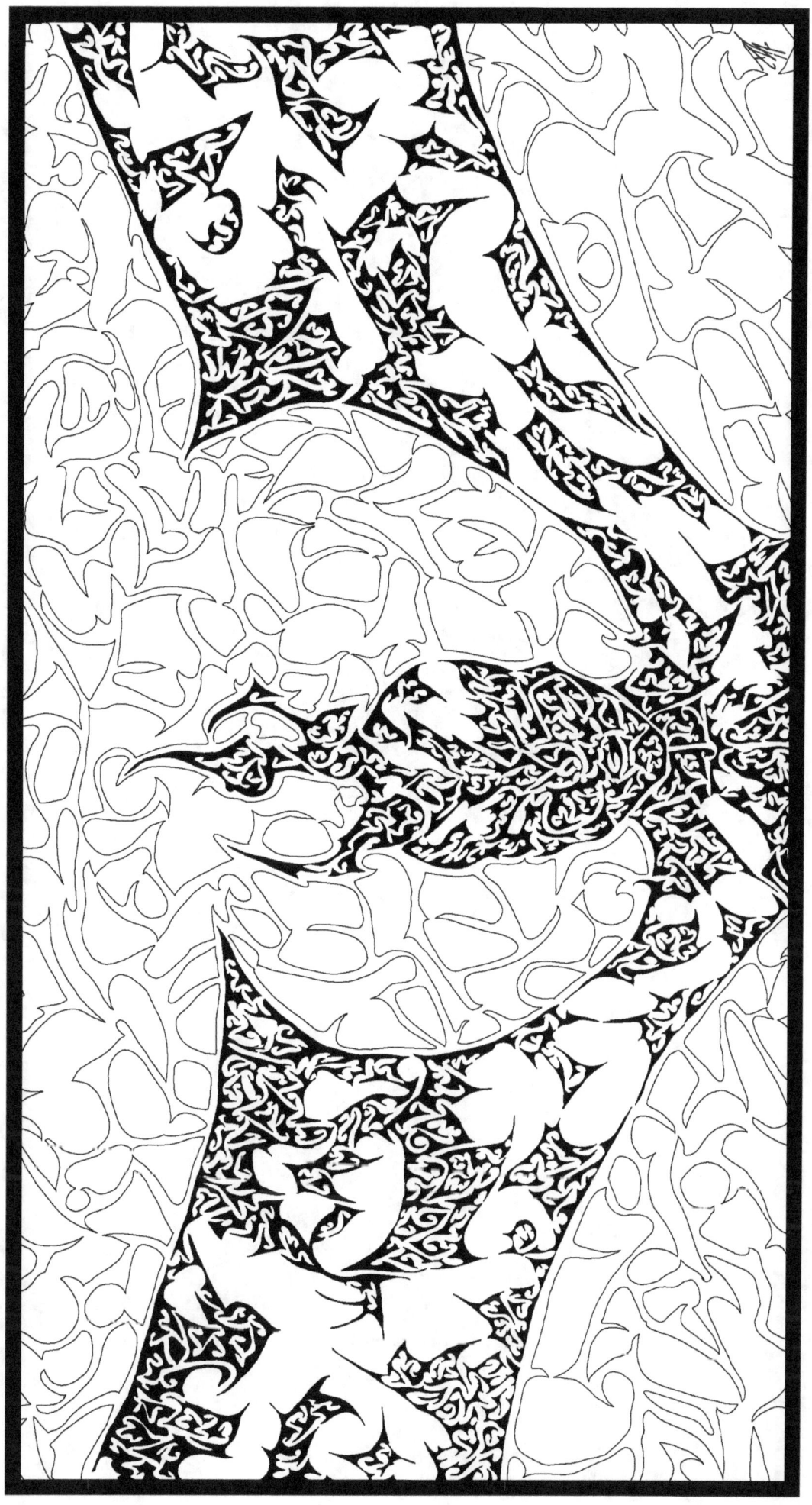

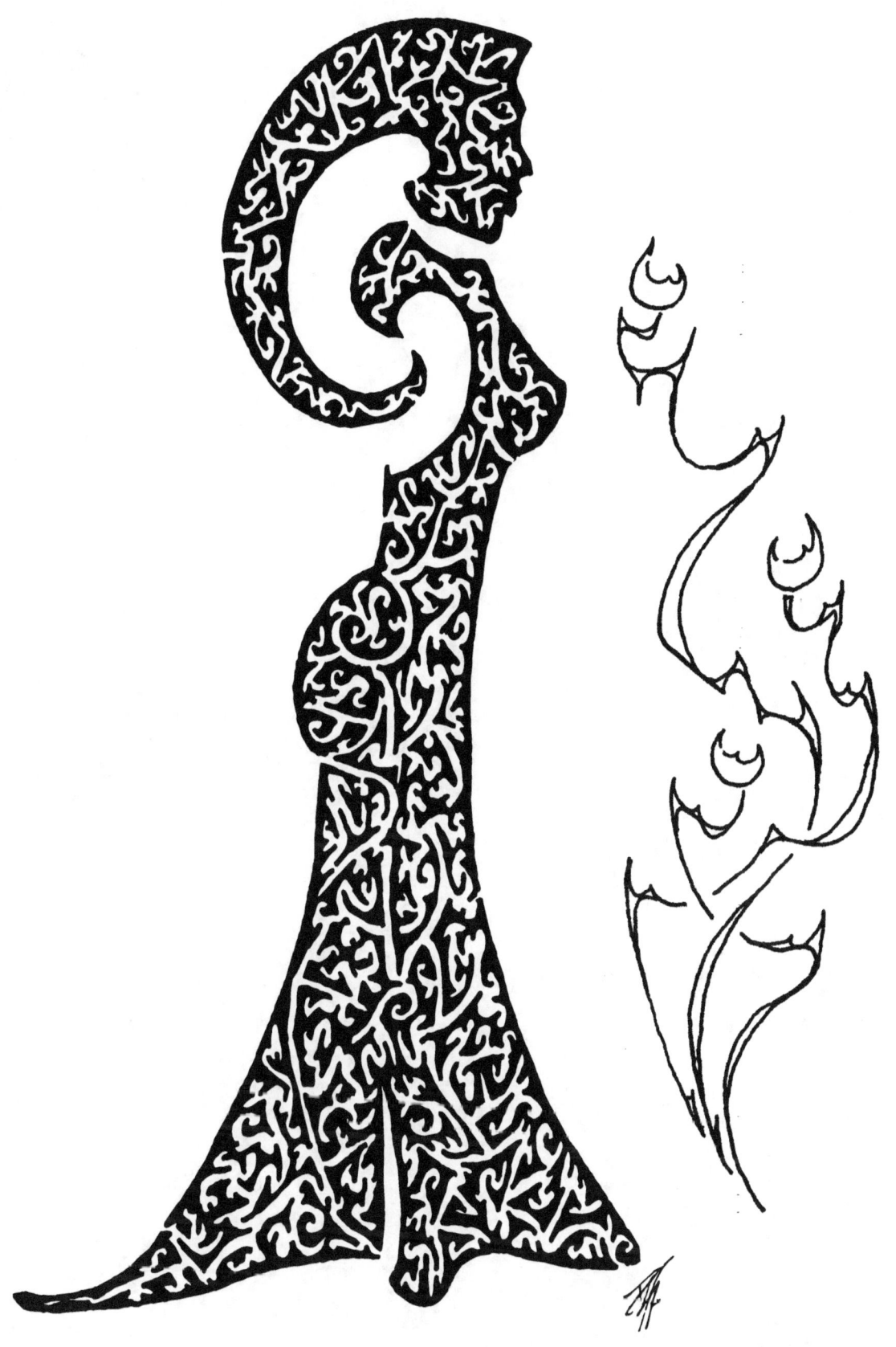

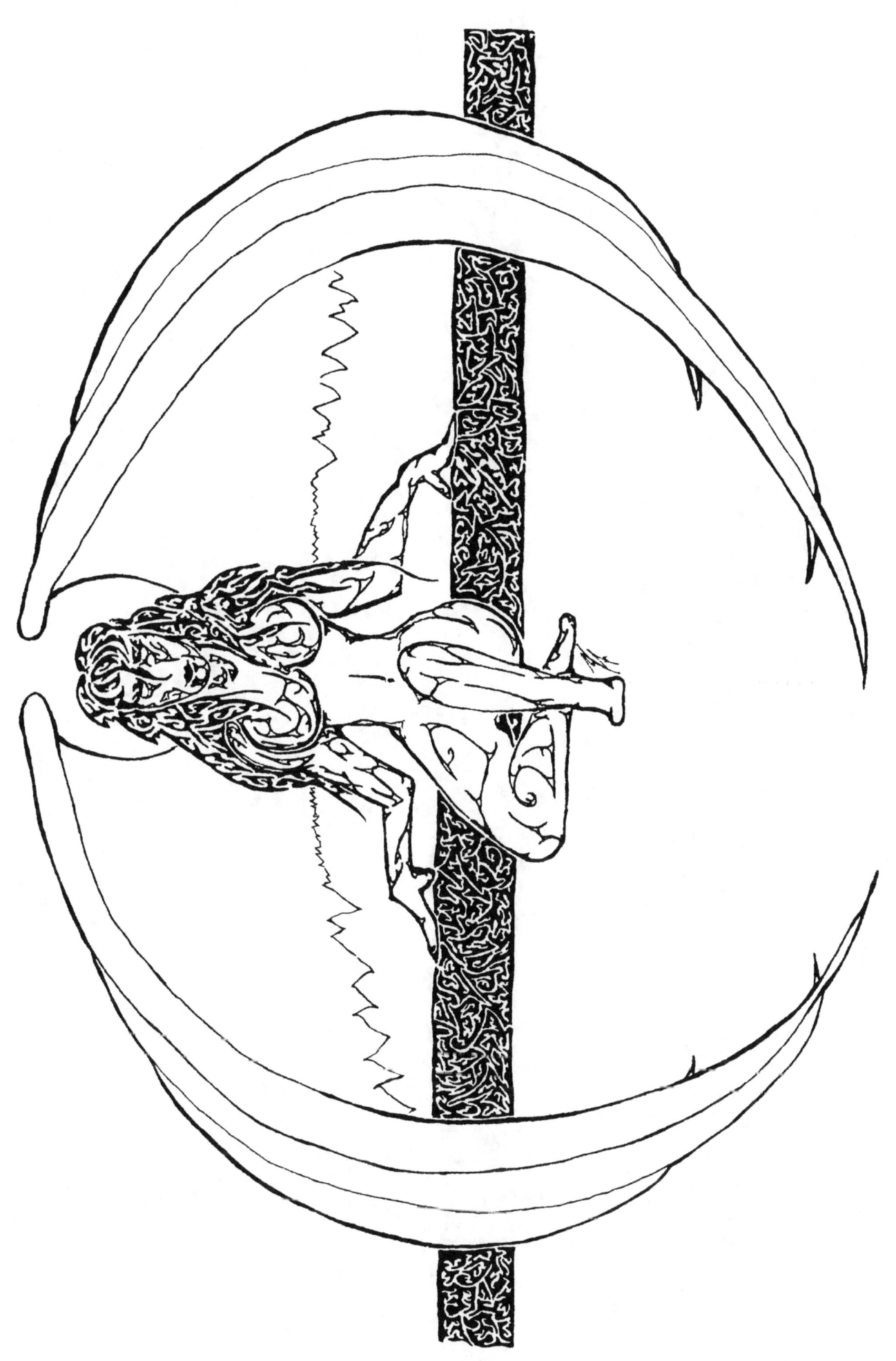

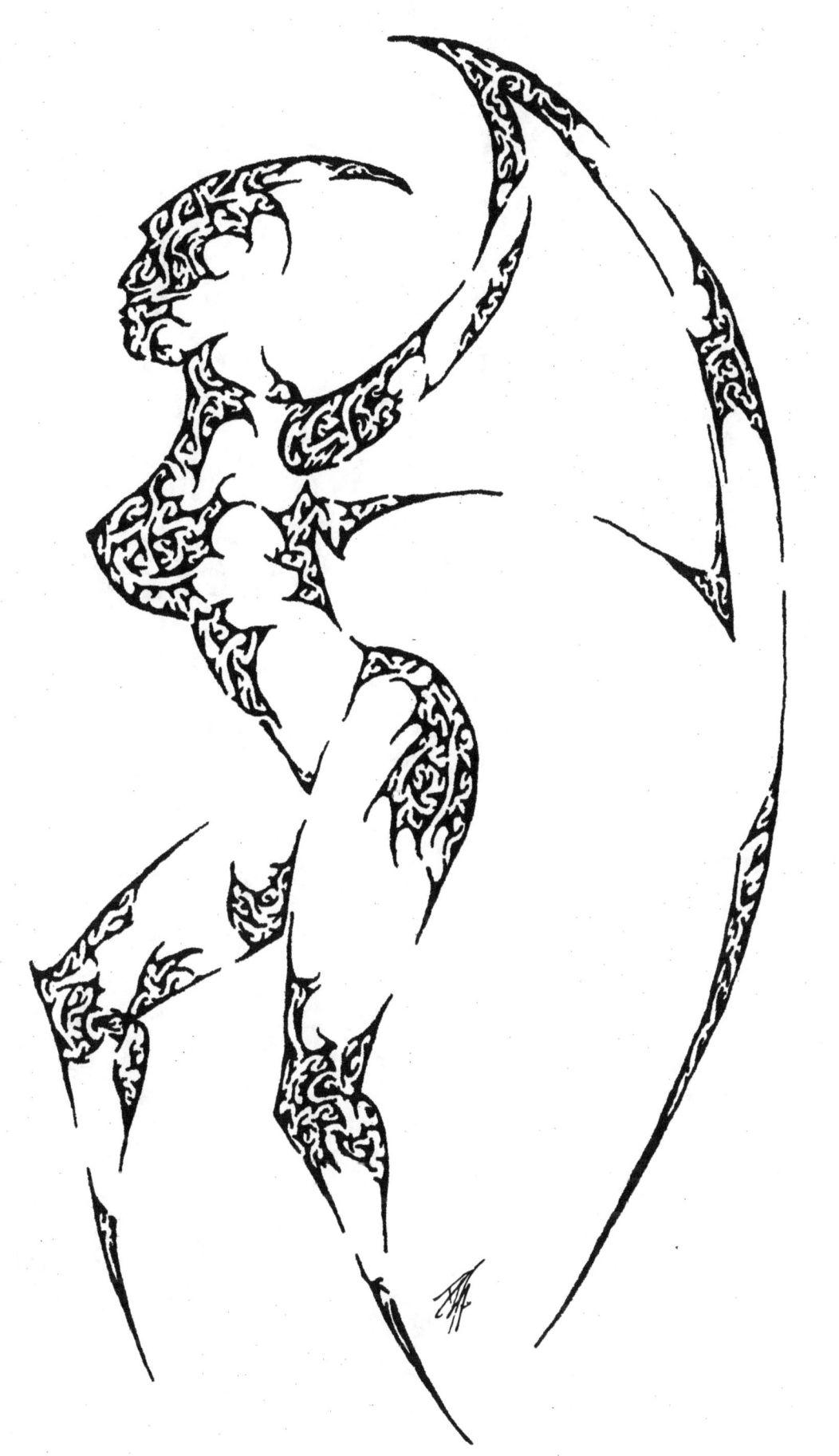

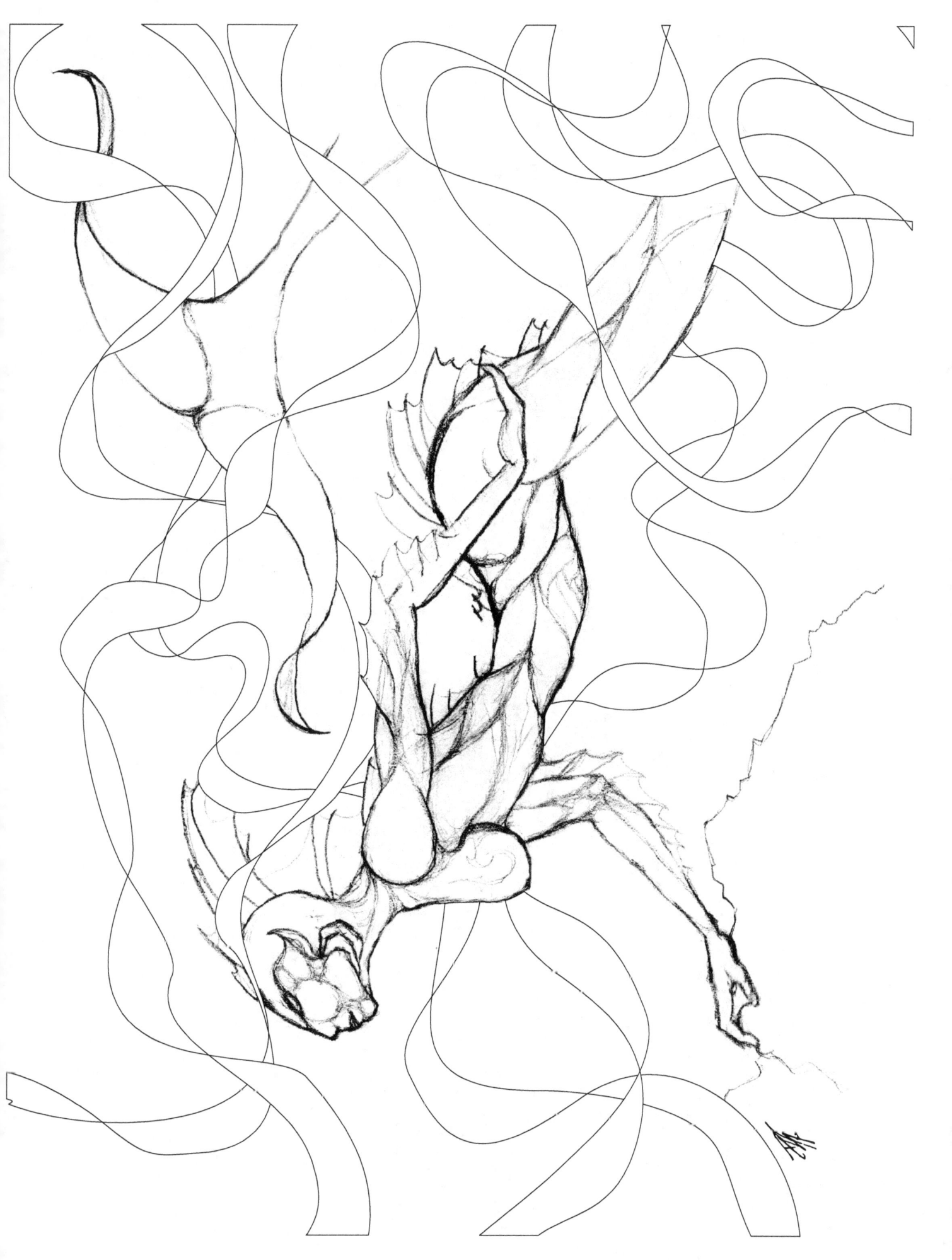

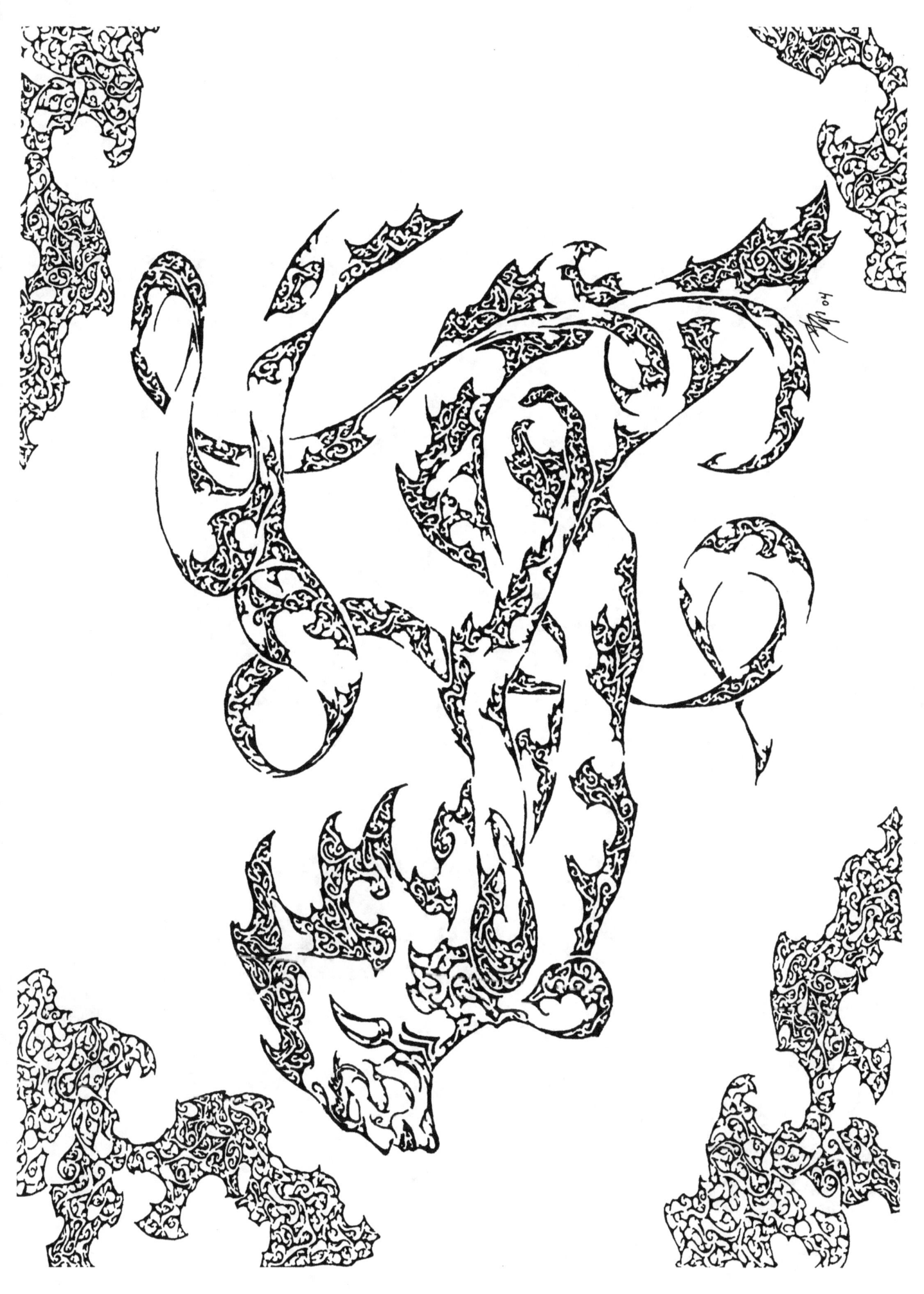

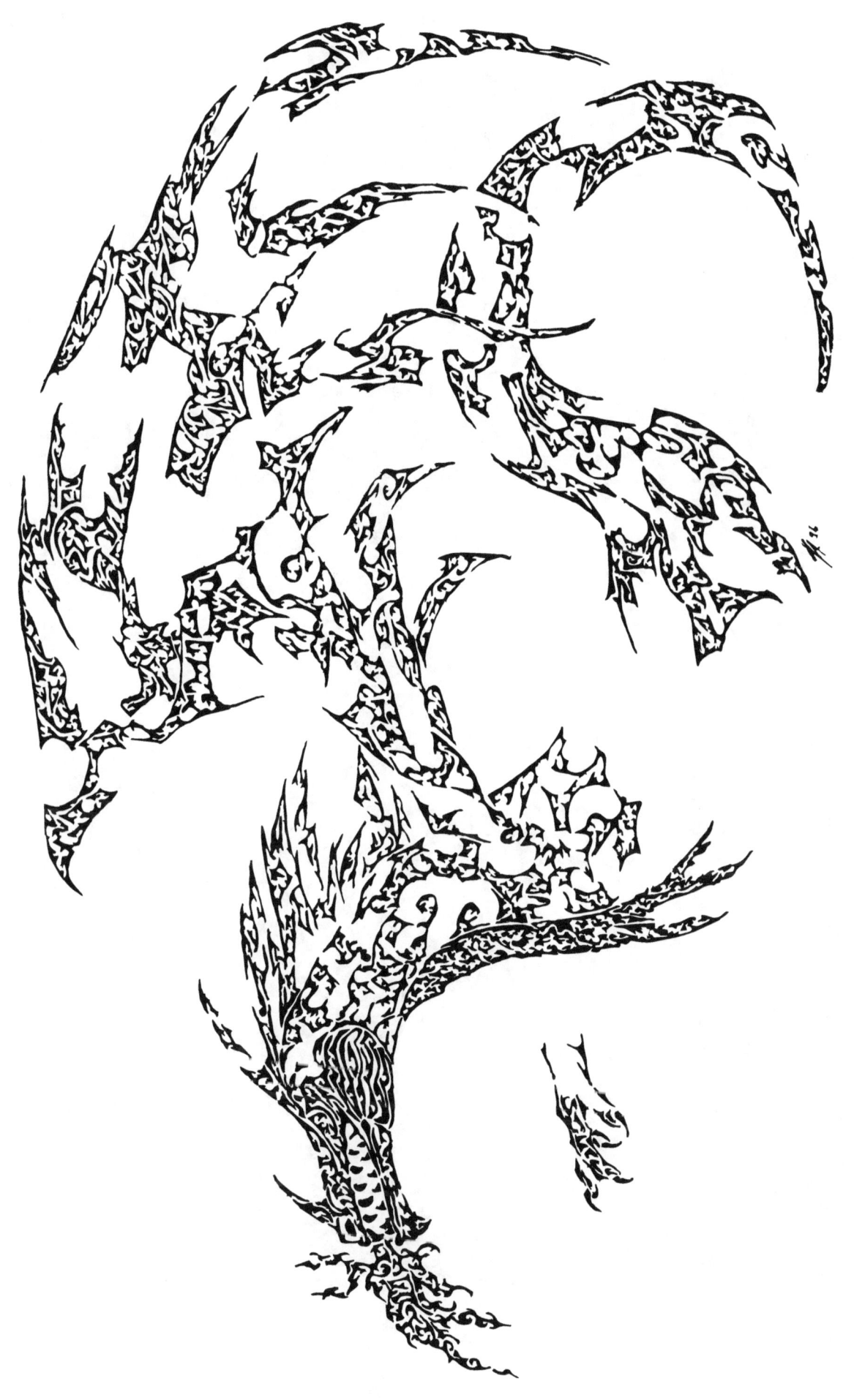

The testing page. The more watery the media the more it will bleed thru the paper.

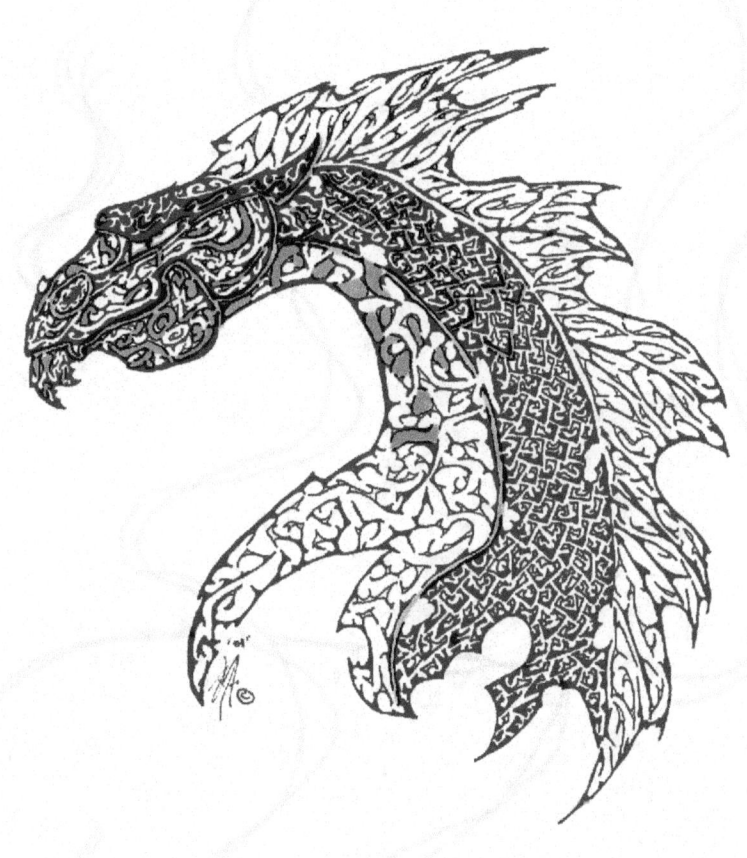

The testing page. The more watery the media the more it will bleed thru the paper.

Enjoy more of my art in my other coloring books

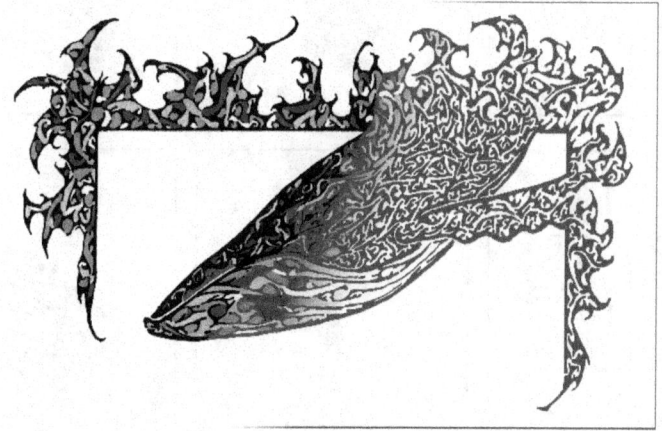
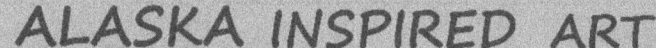
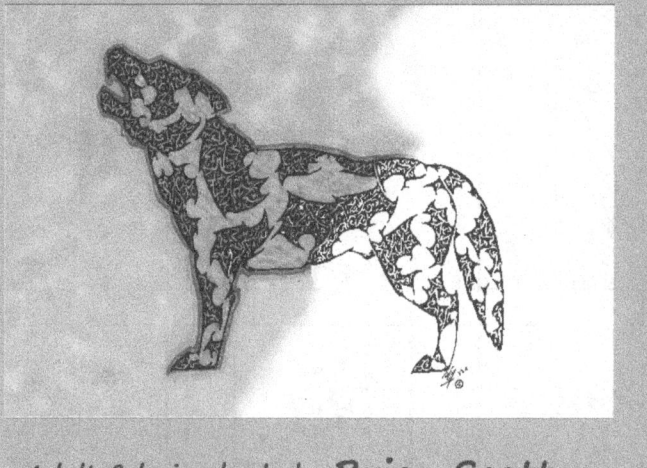
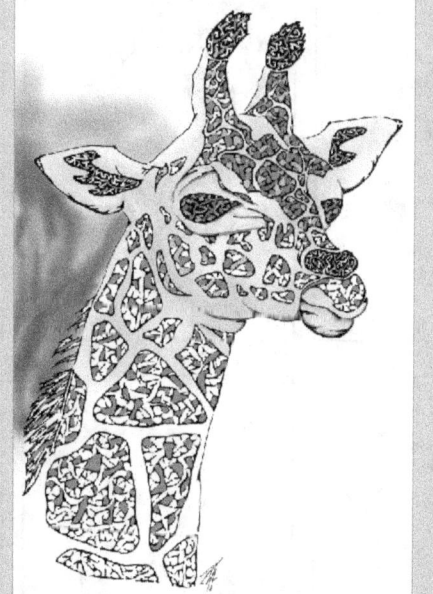

Dragon | Angle | Fire Imp | Fiddler

Part of the: Inspired Art Coloring Books Series

by Brian Scott

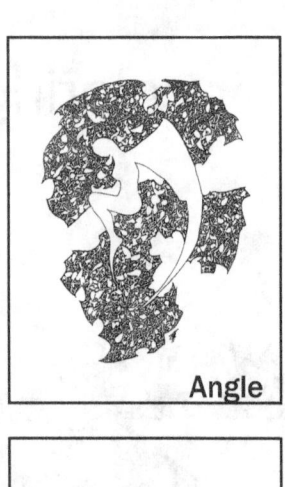 Dragon head
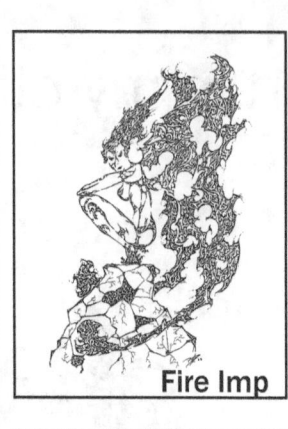 Mermaid
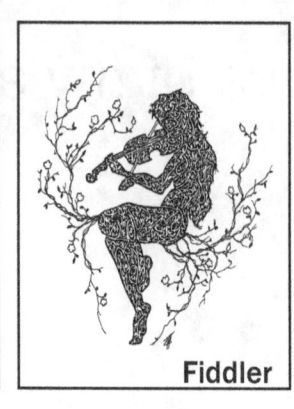 Elements Dragon Compos
 Earth Dragon

Air Dragon

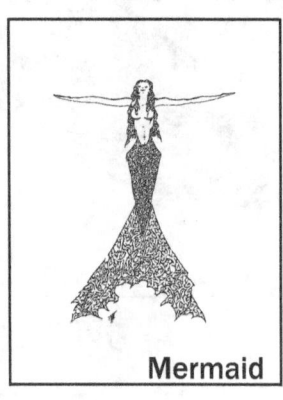 Fire Dragon
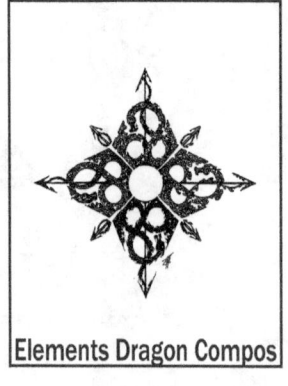 Water Dragon
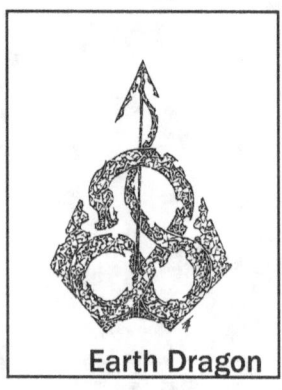 Priestess
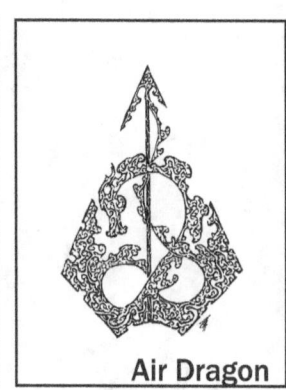 Earth Spirit

Demon breathing fire

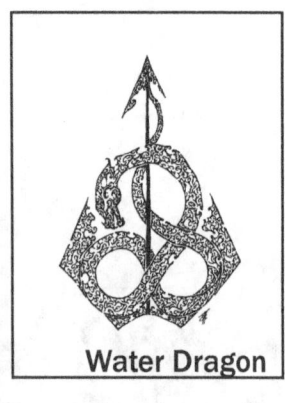 Unicorn head
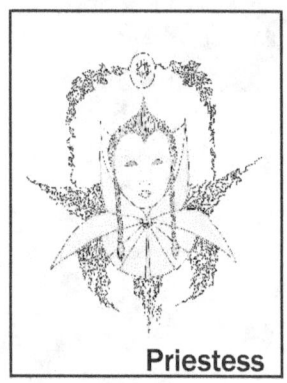 Dragon
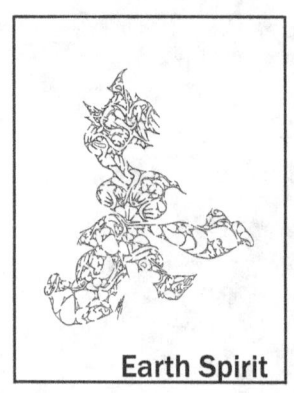 Mermaid
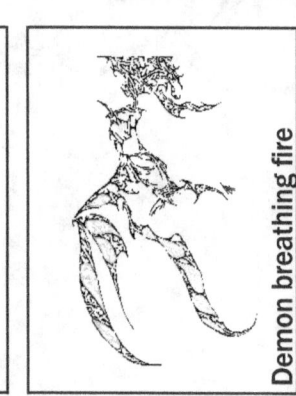 Demoness
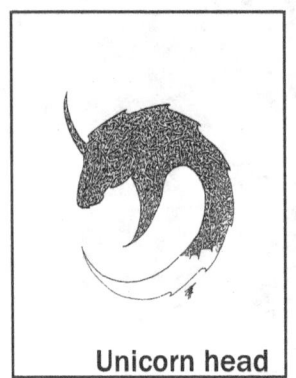 Woman w/Flowers

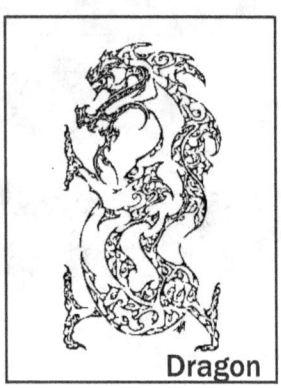 Angle
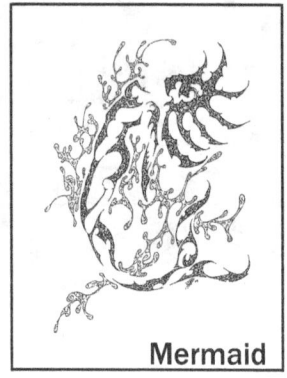 Demoness
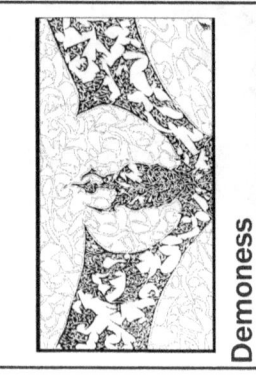 Mermaid
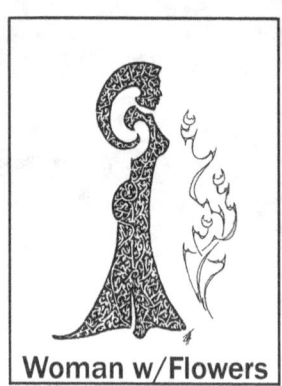 Mermaid
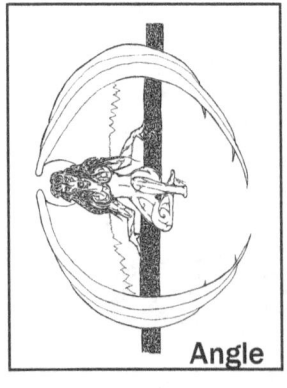

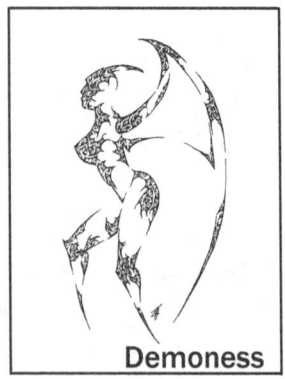
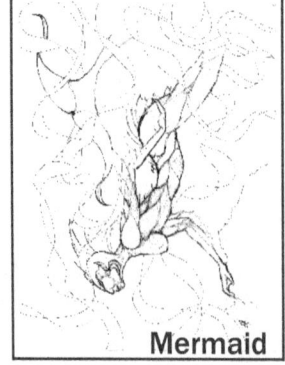
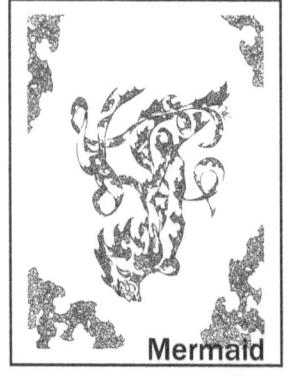
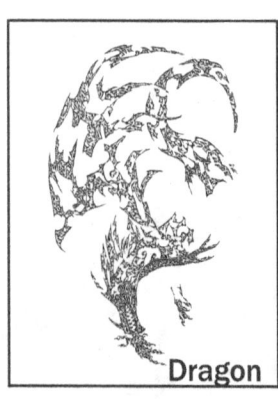 Dragon

www.ingramcontent.com/pod-product-compliance
Lightning Source LLC
Chambersburg PA
CBHW080843170526
45158CB00009B/2614